This Colorig Book Belongs To

Copyrights 2019
Mahmoud Osman

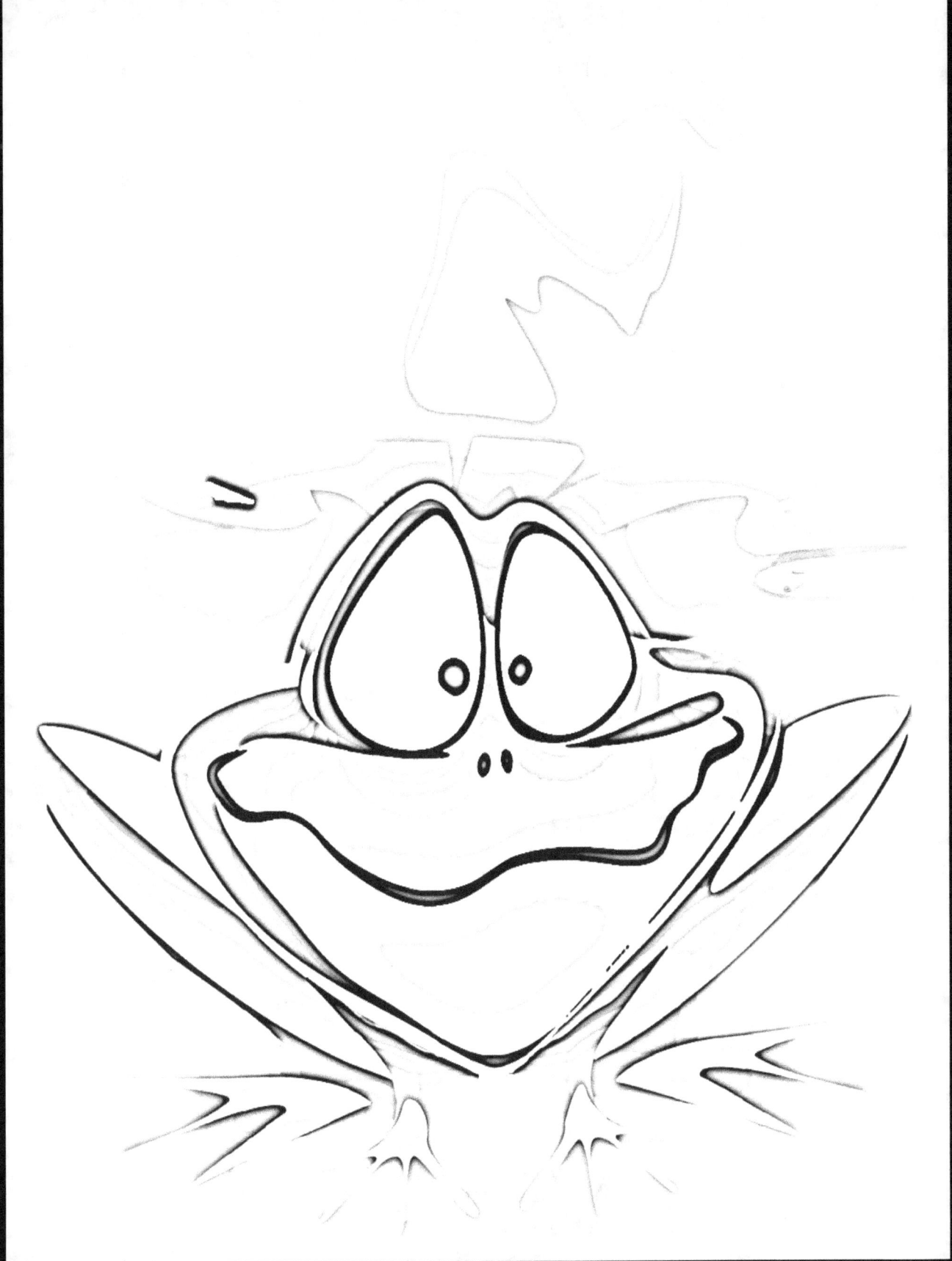

AMPHIBIAN

ANIMAL PAT

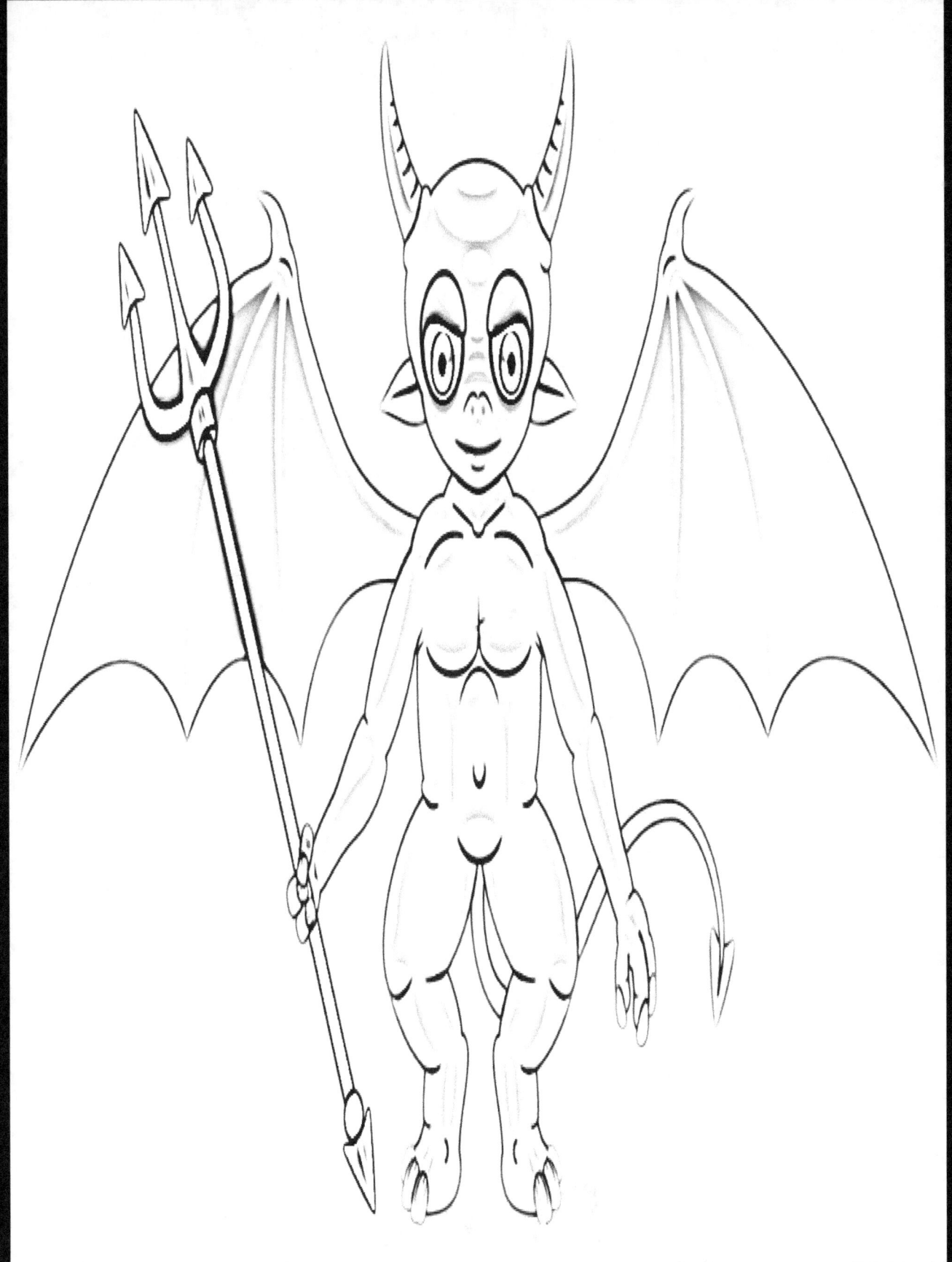

DEVIL

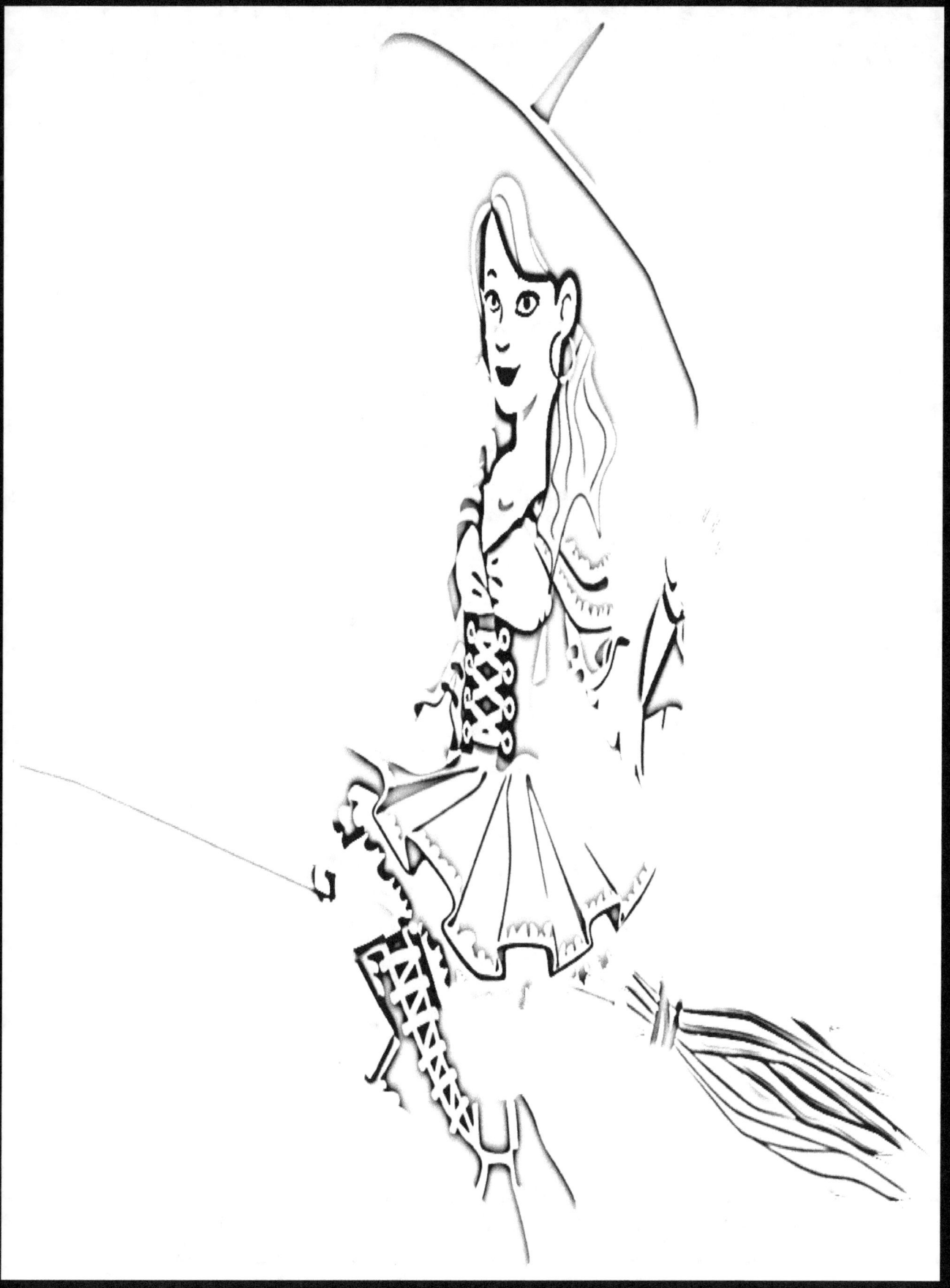

BROOMSTICK

mistletoe

guard

hallwoeen boy

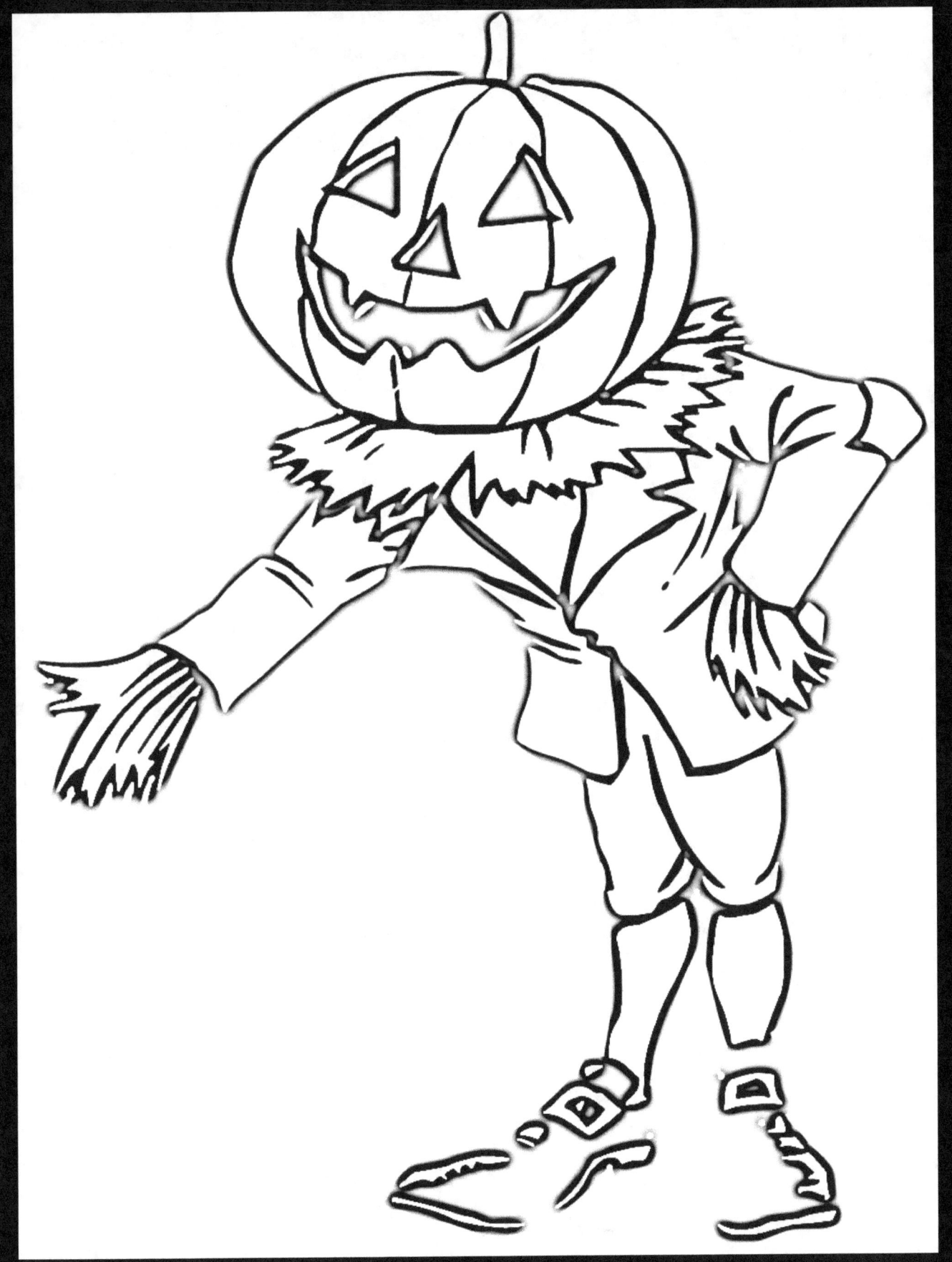

BUMPKIN MAN

BOO GHOST

BUMPKIN SKULL

bumpkin

angry bumpkin

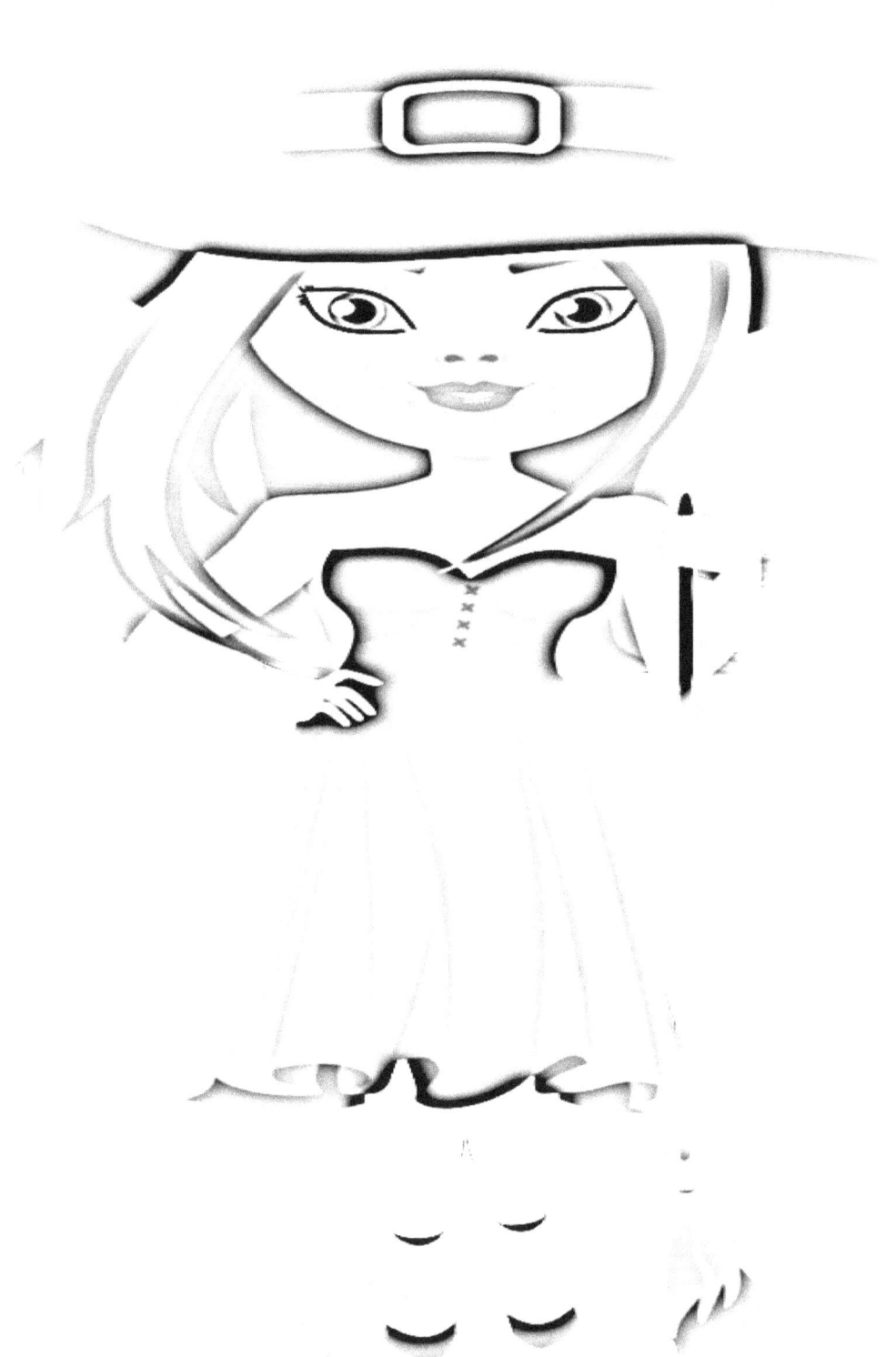

WITCH

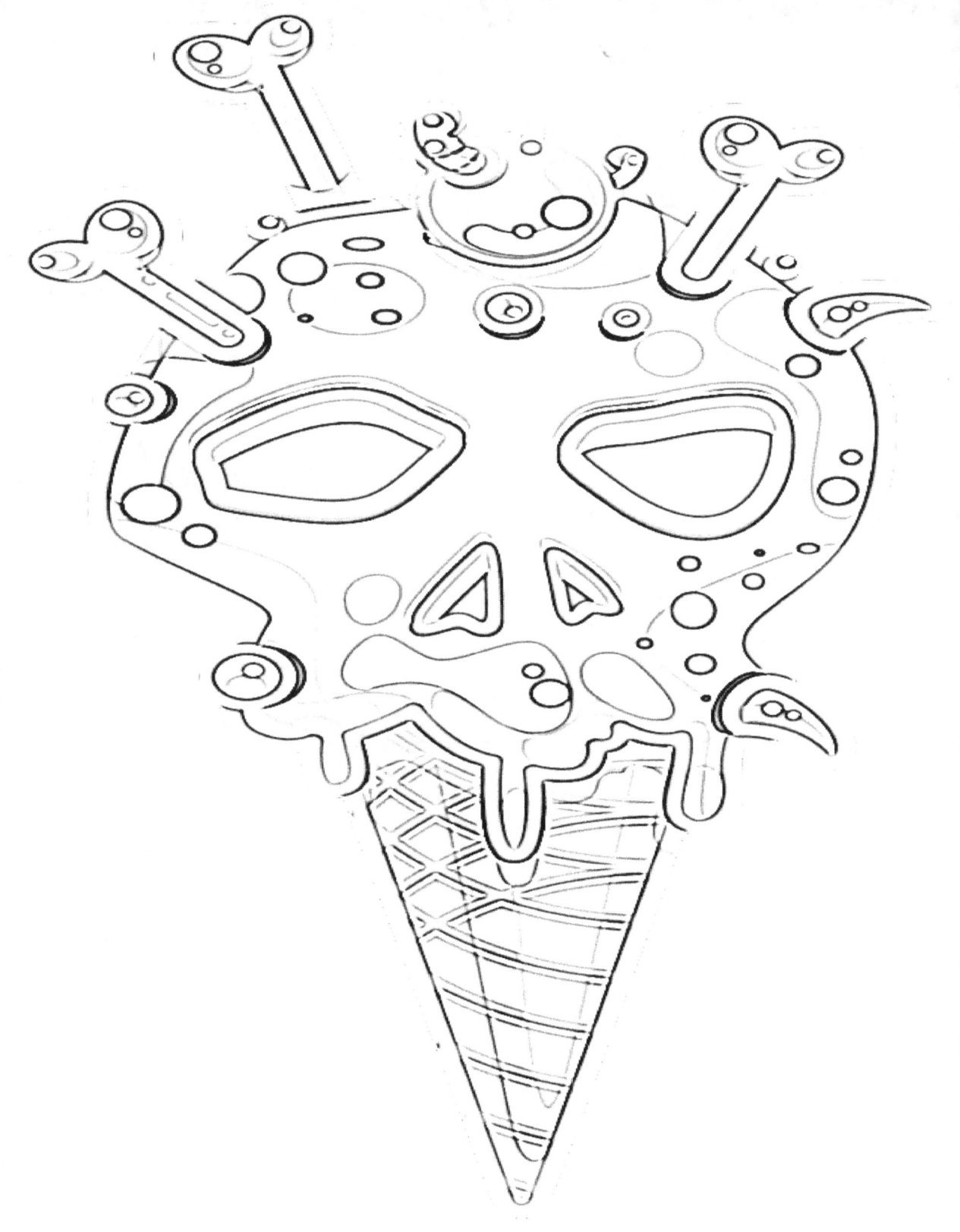

hallwoeen is cream

www.ingramcontent.com/pod-product-compliance
Lightning Source LLC
Chambersburg PA
CBHW081708220526
45466CB00009B/2919